To:

From:

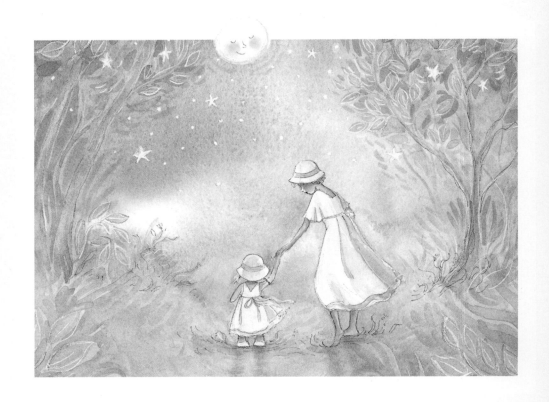

My Mother Gave Me the Moon

Illustrated by Becky Kelly

Written by Patrick Regan

Andrews McMeel Publishing

Kansas City

www.andrewsmcmeel.com

www.beckykelly.com

07 EPB 10 9

ISBN-13: 978-0-7407-3519-6
ISBN-10: 0-7407-3519-5

Illustrations by Becky Kelly
Design by Stephanie R. Farley
Edited by Jean Lowe
Production by Elizabeth Nuelle

For my mother.
-P.R.

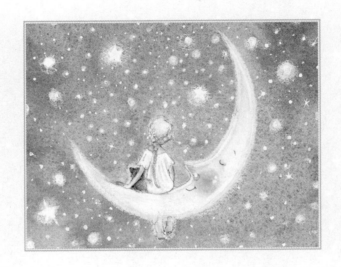

My Mother
Gave Me the Moon

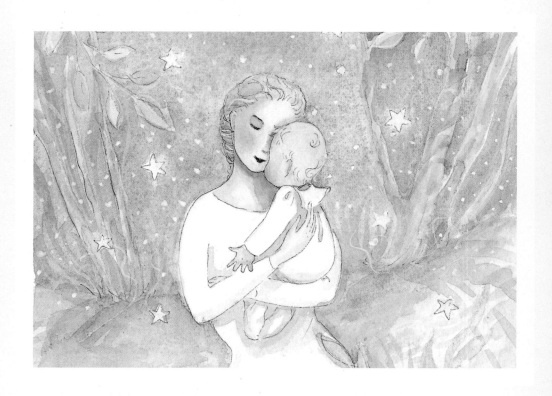

My mother gave me the moon.

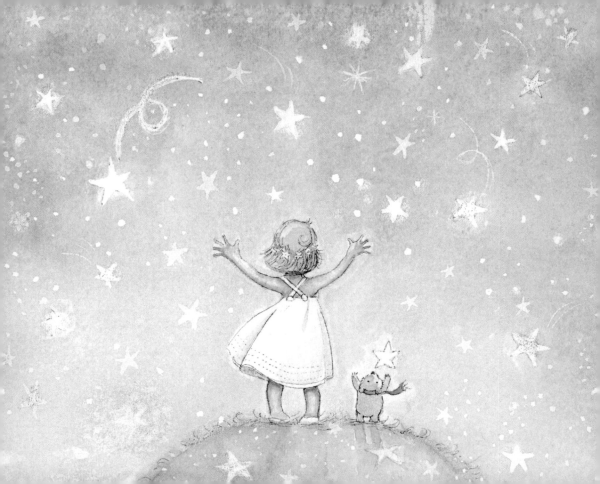

My mother gave me the stars.

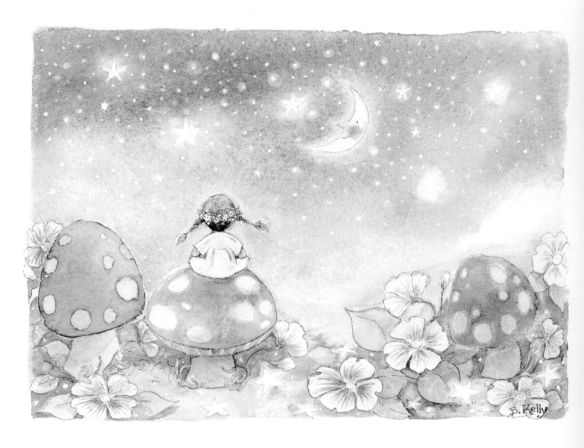

My mother gave me the universe
and all its little miracles.

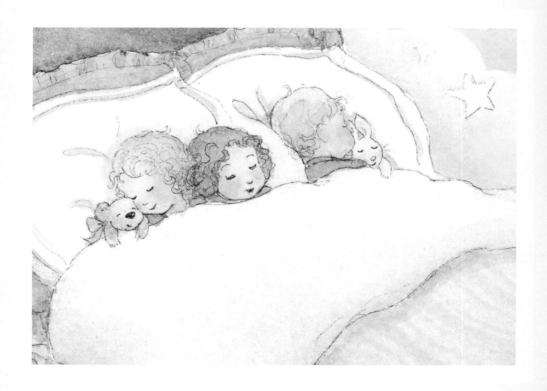

My mother gave me warmth.

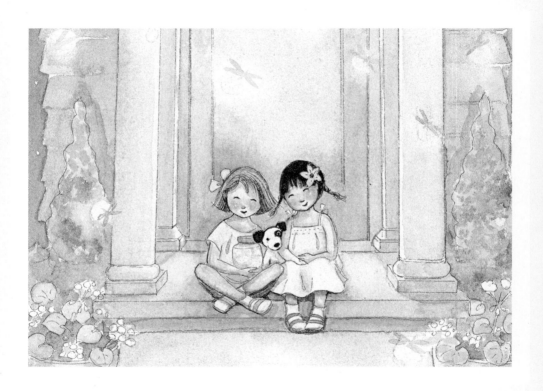

My mother gave me security.

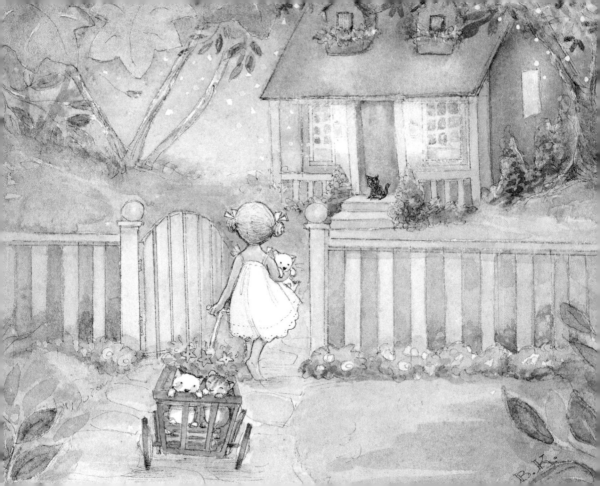

And all the while, my mother gave me room to grow
And the freedom to discover the world for myself.

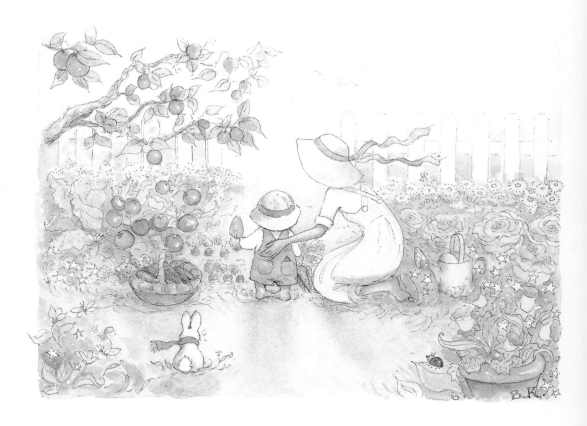

My mother gave me
the gift of countless sunny afternoons...

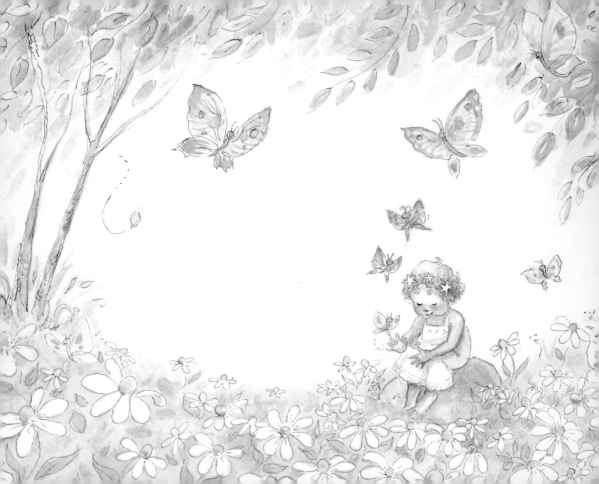

Of wheelbarrow races
and butterfly chases,

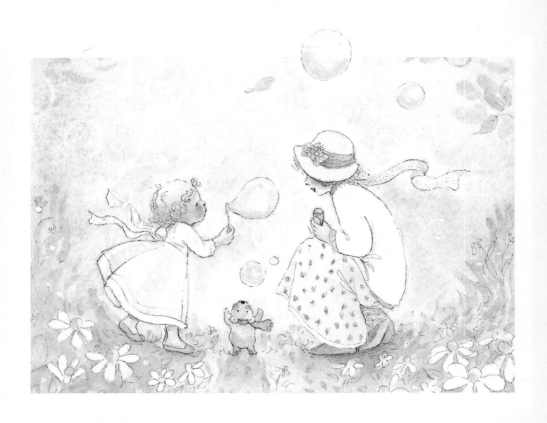

Bubbles of all sizes
and sweet surprises.

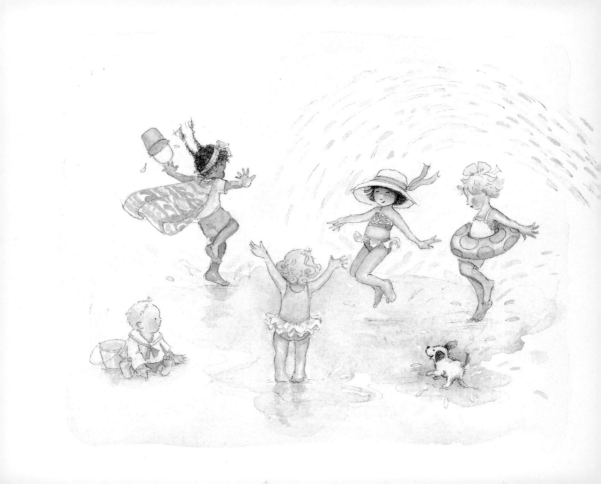

My mother gave me childhood,
pure and joyful.

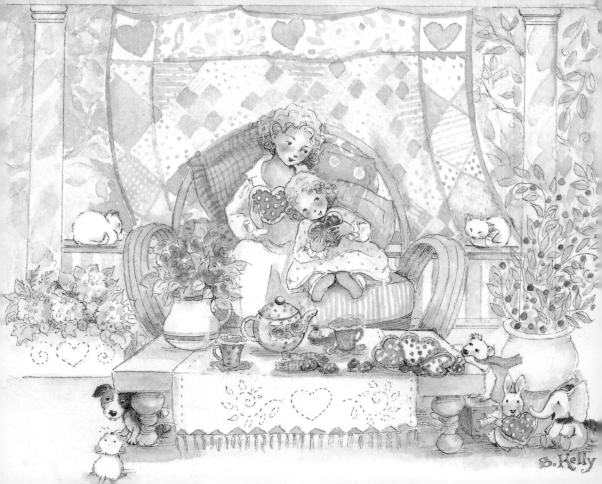

My mother gave me friendship.

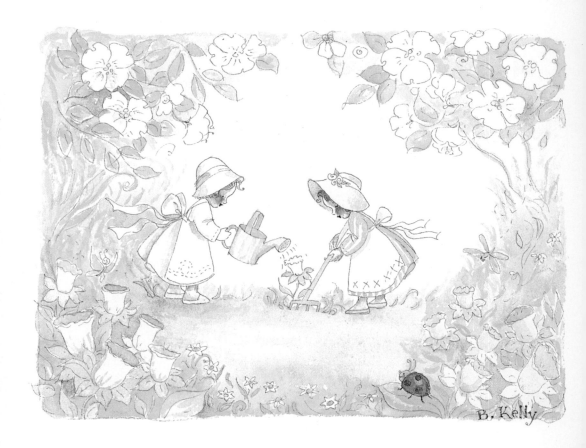

My mother gave me faith.

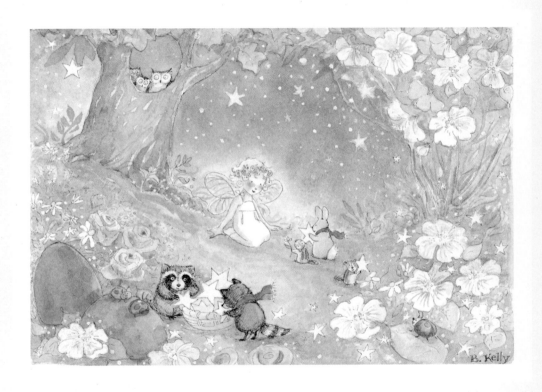

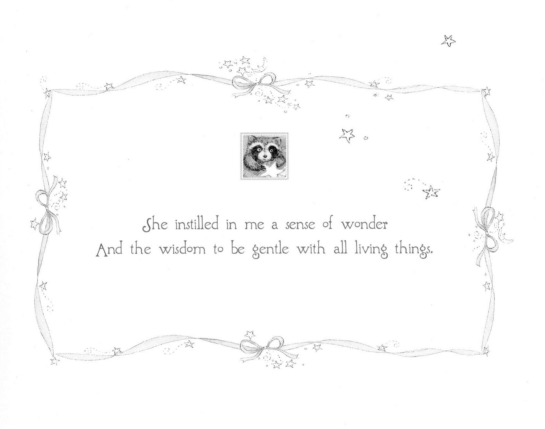

She instilled in me a sense of wonder
And the wisdom to be gentle with all living things.

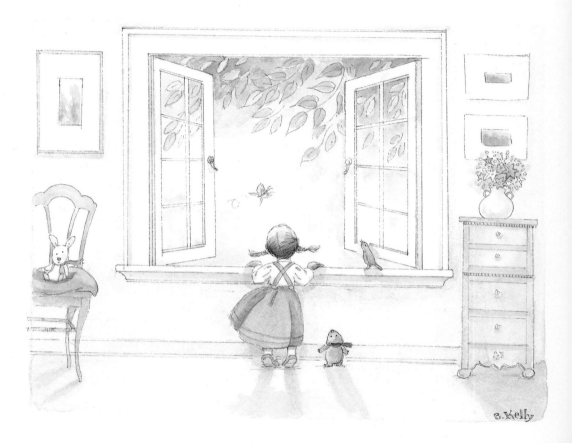

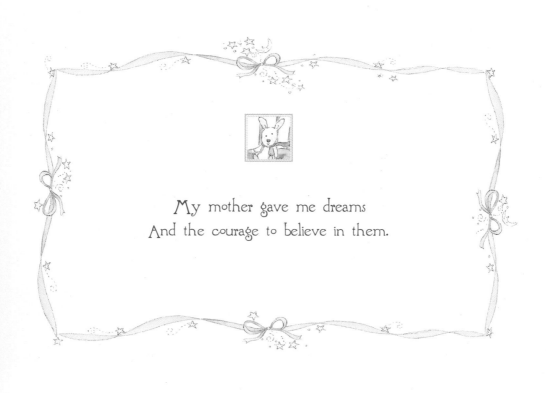

My mother gave me dreams
And the courage to believe in them.

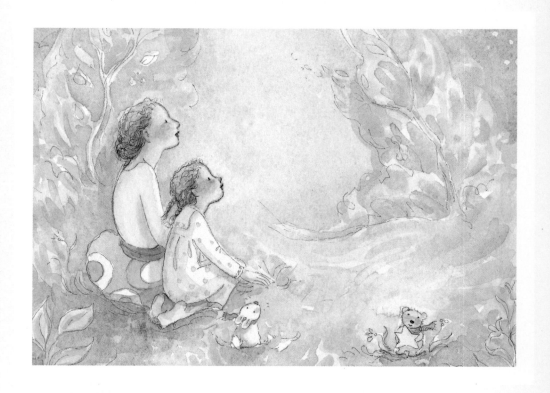

And she still does.

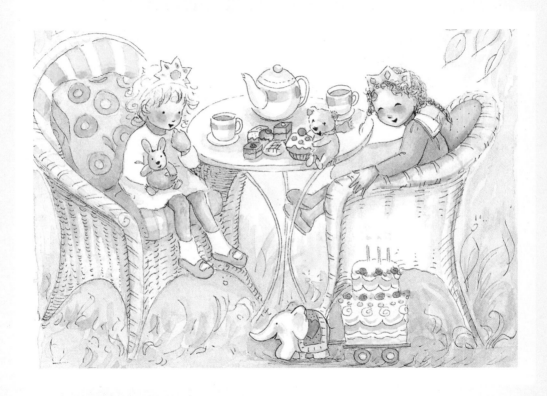

My mother made everday days seem special.

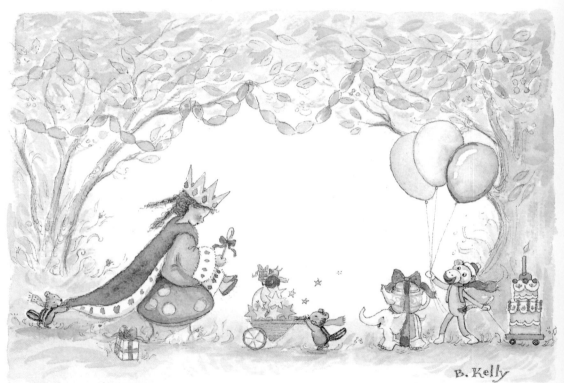

And made special days nothing short of magical.

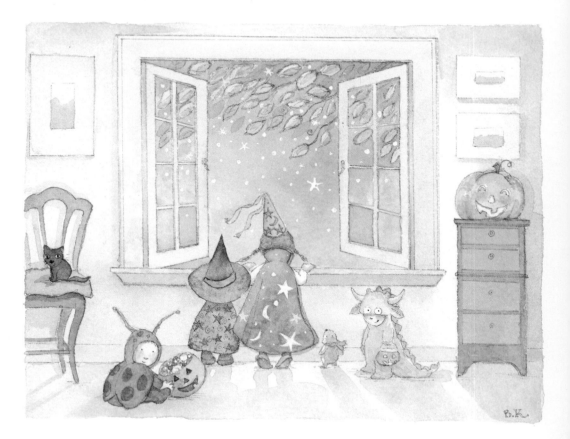

She taught me to hold traditions dear...

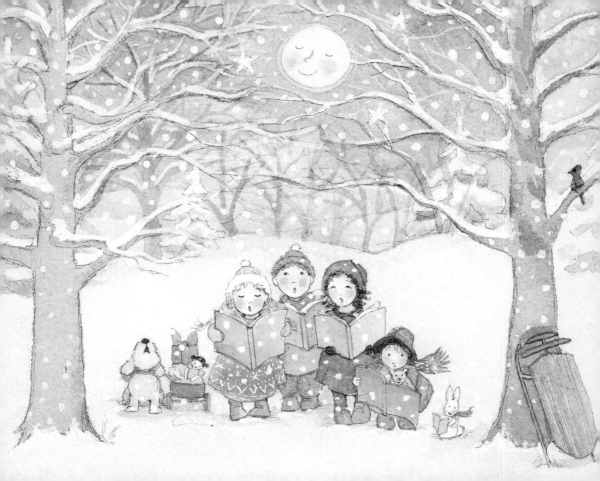

And family close.

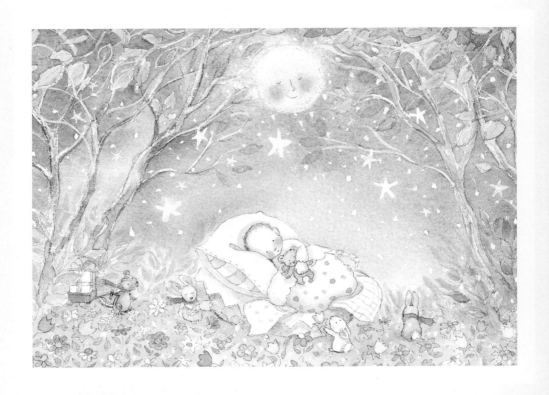

And long before anyone else did...

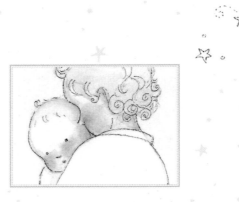

My mother showed me what love really is.